MW01484813

IMAGES
of America

BOWIE

ON THE COVER: This is the Belair Mansion as it appeared around 1900. (Courtesy of City of Bowie Museums.)

IMAGES
of America

BOWIE

Pamela Peck Williams
and Yoku Shaw-Taylor
with the City of Bowie Museums

ARCADIA
PUBLISHING

Copyright © 2016 by Pamela Peck Williams and Yoku Shaw-Taylor with the City of Bowie
 Museums
ISBN 978-1-4671-1660-2

Published by Arcadia Publishing
Charleston, South Carolina

Printed in the United States of America

Library of Congress Control Number: 2015957331

For all general information, please contact Arcadia Publishing:
Telephone 843-853-2070
Fax 843-853-0044
E-mail sales@arcadiapublishing.com
For customer service and orders:
Toll-Free 1-888-313-2665

Visit us on the Internet at www.arcadiapublishing.com

*Dedicated to the citizens of the city of Bowie, whose history is so
very rich, a place where the present celebrates the past every day*

*And to Maggie, Grayson, Micah, Piper, Hayden, and
Finley, to hopefully inspire a love of history*

CONTENTS

ACKNOWLEDGMENTS

We are grateful to the University Archives and Special Collections Department, Thurgood Marshall Library, Bowie State University; Fannie L. Basim; Holy Family Catholic Church; Huntington Heritage Society; Jack Blevins; Dr. James Jacobs; James Smart; Katherine Hayes; Maryland State Archives–Maryland Commission on Artistic Property; Mike Rauck; Prince George's County Historical Society; Sacred Heart Church; Safeway, Inc.; Steve Miller and the Miller family; Rabbi Steve Weisman and Temple Solel; and Susan G. Pearl for photographs and captions.

Unless otherwise noted, all images are courtesy of City of Bowie Museums.

INTRODUCTION

This is a collection of photo-essays about the history of Bowie, beginning with the settlement of Collington, the plantation farms and grand house at Belair, and the railroad station that created opportunity for growth.

This is also a history about horse racing, planned housing developments and the expansion of community life after World War II, religious diversity and representation, segregation in housing and schools, the promise of public education for all, the success of commerce, and the triumph of the spirit of the people and citizens to make a hometown that welcomes all.

The Historic Properties Division of the City of Bowie is dedicated to preserving this narrative of the people, places, events, and the material and cultural legacy that have defined Bowie over the past three centuries.

One

COLLINGTON,
HUNTINGTON, AND BOWIE

Bowie's beginning is rooted in the earliest history of Maryland and Prince George's County. In 1696, the Council of Maryland divided Prince George's County into six hundreds: Mattapany, Petuxant, Collington, Mount Calvert, Piscattoway, and New Scotland. By modern geographic boundaries, Collington Hundred stretches toward Collington Road (Maryland Route 197), embracing portions along Route 450 toward the Belair Mansion, and encompassing much of modern Bowie.

Dotted with small tobacco plantations, Collington was also the location of a large one; Belair Plantation was built in the early 1740s by Gov. Samuel Ogle. By 1800, the Duckett family had built Fairview, which would become the home of the Bowie family in later years.

In 1870, after almost 20 years of planning—and after the Civil War—the railroad came to the area. The Baltimore & Potomac Railroad, planned by the Bowie family, was chartered and later absorbed by the Pennsylvania Railroad. The coming of the railroad to the area spurred developer Ben Plumb to plan a town with spacious homes, stores, and places of worship at the junction of the line to Washington, DC. The new village was called Huntington City. The town renamed itself Bowie in 1882 in honor of Oden Bowie's influence in bringing the railroad to town. In 1911, the Bowie Normal School, today's Bowie State University, opened. In 1914, the Southern Maryland Agricultural Society opened Bowie Race Track, and on April 18, 1916, the area was incorporated as the town of Bowie.

For many years, this area was a rural farming community with Huntington/Bowie as its focal point. Then, in the late 1950s, a dramatic change occurred. Belair Farm/Belair Stud was sold. The purchaser was developer William J. Levitt, who began a suburban community called Belair-at-Bowie several miles south of Huntington City/Bowie. That development was annexed to the town of Bowie in 1959, and the face and geography of Bowie changed forever.

Today, Bowie is a vibrant city of over 18 square miles, filled with residences both old and new and home to a diverse population of over 56,000 residents. Local amenities include a large regional shopping center, small locally owned businesses, museums, parks, a gymnasium, an accredited senior center, and a hockey rink. Many different faith communities and excellent schools also contribute to the Bowie community and quality of life.

Proceedings of the Council of Maryland, 1696/7-98. 23

Stepney Parish Consists of Wiccocomoco and Nantecoke Lib. H. D.
Hundreds.

Vestrymen for the s⁴ Parish as by Return Vi⁷
M⁷ John Huett Clergym⁷

M⁷ Jam:Weatherley ⎫ M⁷ Robert Collyer
M⁷ John Bounds ⎬ M⁷ Thomas Holebrooke ⎫ Taxables 381
M⁷ Philip Carter ⎭ M⁷ Philip Askue ⎭ A⁷ 96. 362.

Snow hill Parish Consists of Bogettenorton & Mattapany
Hundreds. Vestrymen for the s⁴ Parish as by Return Vi⁷

M⁷ Matt: Scarborough ⎫ M⁷ Thomas Pointer ⎫
M⁷ W⁷ Round ⎬ M⁷ Thomas Selbey ⎬ Taxables 353.
M⁷ John ffrancklin ⎭ M⁷ Edward Haffiond ⎭

An Acco⁷ of the Hundreds in the Severall Counties of the
Province Vi⁷

Calvert County is divided into Six Hundreds Vi⁷

Lyons Creeke ⎫
Lower End of the Clifts ⎪
Upper End of the Clifts ⎬ Hundreds.
Hunting Creek ⎪
Leonards Creek ⎪
Elton Head ⎭

Prince Georges County is divided into Six Hundreds Vi⁷

Mattapany ⎫
Petuxant ⎪
Collington ⎬ Hundreds.
Mount Calvert ⎪
Piscattoway ⎪
New Scotland ⎭

S⁷ Maries County is divided into Ten Hundreds besides
the City, Vi⁷

Resurrection ⎫ Poplar Hill ⎫
S⁷ Maries ⎪ S⁷ Maries City ⎭
New Town ⎪
Choptico ⎪
S⁷ Michaells ⎬ Hundreds.
S⁷ Georges ⎪
S⁷ Inego's ⎪
S⁷ Clements ⎪
Harvy ⎭

These are the proceedings of the Council of Maryland in 1696. In 1695, Prince George's County was created from parts of Calvert and Charles Counties and named for the husband of Queen Anne, Prince George of Denmark. The following year, the Council of Maryland formally divided the new county into six hundreds. Collington was one of those hundreds.

Collington, like most of 17th- and 18th-century Maryland, was comprised of small plantations growing subsistence crops and cultivating tobacco as a cash crop. Any evidence of the plantations scattered across Collington Hundred has long disappeared. According to historical notes from the Prince George's County Historical Society, the Confederate guerilla John Boyle was captured by Union captain Thomas Watkins at Collington in 1864. In 21st-century Bowie, with modern development and commercial activity, it is difficult to imagine these small, ephemeral structures, surrounded by fields that provided food and a livelihood. (Courtesy of the Prince George's County Historical Society.)

The oldest section of Fair Running (sometimes called the Maenner House) was built on land known as Isaac's Discovery. The stone structure is one of only two surviving examples of early-18th-century domestic architecture in Prince George's County and the only early example in Bowie. Begun by Joseph Peach in 1727, the house was enlarged in 1802 by his grandson. The Maenner family, upon purchasing the house in 1885, added another wing. Fair Running, owned today by the City of Bowie, serves as the clubhouse and restaurant for the Bowie Golf Course.

Fairview was for many years the home of the Duckett and Bowie families. Built around 1800 for Baruch Duckett, it is a blend of architectural styles, with a Georgian Palladian exterior and lovely Federal-period trim interior components. A modern housing development surrounds Fairview today. The developer has secured and interpreted a number of building foundations (including an early Thoroughbred barn) associated with the plantation. A family graveyard close by is testimony to the generations of Ducketts and Bowies who called Fairview home. Among others, Gov. Oden Bowie (1824–1896) is interred in the graveyard. (Courtesy of the Prince George's County Historical Society.)

11

This street map detail of Huntington City (Bowie Station) is from the *Atlas of Fifteen Miles Around Washington, Including the County of Prince George*. The map, published in 1878, not only offers a view of the scheme of Huntington City's street plan but also indicates the homes of several residents. At its founding, the new village was called Huntington City. Some historians think the city was named in honor of 19th-century railroad financier Collis P. Huntington. The railroad station itself, however, has always been known as Bowie Station. Today, streets in the Huntington section of Bowie still have this same grid pattern, with the same name and number system planned by Ben Plumb.

This map of Queen Anne District Number 7 is also from the *Atlas of Fifteen Miles Around Washington, Including the County of Prince George*. It gives a clear view of the rural nature of the area surrounding Huntington City. A number of families owning farms in the surrounding area also owned houses in town. Note that by 1878, other well-known areas of the county—Glenn Dale and Springfield, for instance—had already been established.

12

Although the village surrounding the railroad depot was called Huntington City, the station has been, since its earliest days, Bowie Station, in honor of Oden Bowie. This photograph offers a look at the lovely Victorian elegance of early railroad stations. Wooden boardwalks across the tracks gave access to the southbound track for riders heading to Washington, DC, and points south. Bowie Tower was an interlocking tower, one of many that used a series of heavy handles and levers to activate switching on tracks, a critical and important part of rail safety. The rods (which were connected to the interlocking machine inside the tower) were contained in metal conduits, visible in the lower left of the photograph, alongside the track.

The Popes Creek passenger train and crew members are pictured in 1906. The railroad was one of the largest employers in Huntington City. Pictured at left are local men who served on the Pope's Creek Line passenger train. From left to right are "Pokey" Morris, who delivered mail from the train to the post office; Houston Morris, express clerk; Warren Houck, conductor; William Thirles, brakeman; Edward Lancaster, baggage master; John W. Ryon, mail clerk; Luke Seitz, fireman; and West Charters, engineer. The Seitz family operated a hotel and bakery. Both Edward Lancaster's and John Ryon's houses have been restored and remain in use today.

Bowie Station was originally owned by the Baltimore & Potomac (B&P) Railroad and was to be a stop on the line to Southern Maryland and Pope's Creek. The B&P had rights to construct a 20-mile spur into Washington, DC, in addition to the Southern Maryland line. The Pennsylvania Railroad, denied permission by Congress to build its own line into Washington, DC, bought the B&P and constructed the spur. The picture here shows the wye created by the spur. The line to Washington, DC, opened in July 1872 and the Pope's Creek line in January 1873. To the left is the Pope's Creek track; to the right is the track into Washington, DC.

Twin Houses, built by the B&P, are undated. The homes were built to temporarily house railroad workers and supervisory personnel while in town on railroad business. They are likely the oldest standing buildings in this part of town today and are privately occupied.

The Frank Luers House, built around 1895 on Tenth Street, stood on one of Ben Plumb's original Huntington City lots plotted in 1870. Built in a classic late Victorian style, the Luers family home contained nine rooms and two stairways. As was typical with many buildings in Huntington City, the house faced the railroad. Today, the structure remains in use as a private residence.

Bird's Eye View of Bowie, Md.

This bird's-eye view of Bowie is from the early 1900s. In March 1874, an act was passed by the Maryland Legislature to incorporate the town of Huntington. The act set up a "body corporate" that was named "the Commissioners of Huntington," with the first municipal election to be held in April. Voting took place at the post office. Eight years later, in May 1882, the incorporation act was amended to change the body corporate to "the Commissioners of Bowie," honoring Gov. Oden Bowie and his role in bringing the railroad to the area. On April 18, 1916, Bowie once again reincorporated, this time as the town of Bowie, adopting a charter still in place 100 years later.

Gov. Oden Bowie was born at Fairview Plantation in 1826. He was tutored at home as a young child. After his mother's death, he was enrolled in the Preparatory School of St. John's College in Annapolis and completed his education at St. Mary's Seminary in Baltimore. After seeing action in the Mexican War, he served in both the Maryland House of Delegates and State Senate. He was Maryland's governor from 1869 to 1872. Bowie was, along with other members of his family, instrumental in bringing the railroad to Prince George's County. An ardent supporter of Thoroughbred racing and breeding, he served as president of the Maryland Jockey Club. The Preakness Stakes, the second leg of the Triple Crown, came to Pimlico Race Track as a result of Bowie's interest in the sport. (Courtesy of the Maryland State Archives–Maryland Commission on Artistic Property.)

The Fladung and Weeks families surround Martin Fladung (center left) and Estella Weeks (center right) at their wedding in 1915. The wedding party stands in front of the Straining House, an Italianate dwelling built around 1870. John Straining, the house's original occupant, purchased a number of lots in Huntington City. The house, still in use as a private residence, was the site of the Bowie Telephone Exchange for a number of years. It is recognized by Prince George's County as a historic structure.

Martin and Vincent Fladung are pictured on a horse-drawn hearse. The Fladung family, among Huntington City's earliest residents, had a number of business enterprises. In addition to operating a blacksmith shop, Martin and Vincent Fladung served as the city's undertakers. In the 19th and early 20th century, mourners frequently paid their last respects in the family homes of the deceased. The Fladung family's funeral parlor was often used by those who were not able to have viewings and wakes in their homes.

The streetscape in Huntington City has changed over the years. Pictured here in the early 1900s at the intersection of Chestnut Avenue and Eleventh Street are businesses frequented by residents. In the distance is the old bridge over the railroad tracks. The buildings housed a livery stable (on the left) and several stores and a barbershop (on the right).

From left to right, Calvert Lancaster, Valerie Lancaster, and Carlyle Lancaster are pictured around 1930. The Lancaster children epitomize Ben Plumb's goal that Huntington City would be a place where "children will be reared away from city temptations." They stand in front of Johnston's Store, the Lloyd family home, and the village's pool room. Members of the family continue to reside in Huntington City/Old Bowie today. Carlyle "Jiggs" Lancaster grew up (in Bowie) to become a veteran of World War II, city attorney, and state's attorney for Prince George's County.

Postmistress Nettie Fowler stands in the doorway of an early Bowie post office, possibly the first. Postal patrons frequently picked up their mail at the post office, since rural free delivery (RFD) was not commonplace until the early 20th century.

As with many small towns and villages in the area, Huntington/Bowie's first fire department was literally a bucket brigade. In 1928, citizens formed the Bowie Volunteer Fire Department, funded by events and contributions. The first firehouse was built in 1928 by Charles Fladung. In 1939, the building shown here was constructed with funds set aside for a town hall. The department had two Ford Model T chemical trucks. For a short time, the firehouse functioned as a town hall. The town suffered three serious fires early in its history. In April 1895, an accidentally overturned kerosene lamp in Seitz's Hotel was thought to be the cause of a fire. A year later, a serious fire occurred in another hotel. The 1910 fire was catastrophic, destroying the entire business district and threatening a number of homes. The railroad signal tower and telegraph lines were destroyed, rendering the town incommunicado for several hours. A new, permanent firehouse was a welcome and necessary addition to the town.

As part of a close and family-oriented community, residents of Huntington City enjoyed many festivals, picnics, ball games, and social events together. At a 1940s Fireman's Parade, local beauties ride a fire engine from Company 19. Today's fire station in Huntington/Old Bowie remains essential to the community's safety and is still classified by Prince George's County as Company 19.

After the tragic death of William Woodward Jr., William J. Levitt purchased the Belair Farm, soon to become a huge residential community, Belair-at-Bowie. After acquiring a strip of land along Routes 197 and 450 connecting his development to what was then Bowie, Levitt approached the city administration in hopes of annexing Belair-at-Bowie to the city. After long discussions and visits to other Levitt developments, the town commissioners signed annexation documents in February 1959. Pictured at the signing are, from left to right, Walter Stewart, town commissioner; Carlyle "Jiggs" Lancaster, attorney for the town of Bowie; Frank Brown, president of the town commissioners; Lawrence Maenner, town commissioner; and Rose Mary Abell, town clerk. The annexation of Belair-at-Bowie changed the face of Bowie forever.

Two

BELAIR MANSION

Built in 1745 for provincial governor Samuel Ogle and his wife, Anne Tasker Ogle, Belair was one of the finest early houses in Prince George's County, Maryland. The exact architect of the structure is unknown. The mansion was constructed in the Georgian Palladian style.

Samuel Ogle was a well-to-do, powerful figure in early Maryland government. His wife was the daughter of a man equally well-to-do and perhaps as powerful. Their plantation home would have reflected the comfort, grace, and elegance their status in life demanded.

Belair enjoyed its share of important visitors. In 1755, after Samuel Ogle's death, his brother-in-law, Col. Benjamin Tasker, became the manager of Belair. Benjamin Franklin visited Colonel Tasker at Belair. While riding, Franklin and Tasker witnessed a small tornado—a whirlwind. Franklin inquired as to whether this was a normal occurrence at Belair. According to Shirley V. Baltz's *Belair from the Beginning,* Colonel Tasker answered pleasantly, "No, not at all common but we got this on purpose as a treat to Mr. Franklin." According to Franklin, "a very high treat it was!" George Washington may have visited Belair. While no records exist to confirm his presence at the plantation, he visited Benjamin Ogle in his Annapolis house and secured a shipment of deer from Belair's deer park for the deer park at Mount Vernon.

Around the time of the War of 1812, Benjamin Ogle I redecorated the house, replacing 18th-century decor with early-19th-century features. In 1871, after the Civil War, the Ogle family was forced to sell the mansion and remaining acreage. For a number of years, a succession of owners paid little heed to maintaining the house.

When James T. Woodward purchased Belair in 1898, he began the second phase of its life, making repairs and additions to the structure that would become his country house. Upon his death in 1910, his heir, William Woodward, undertook several projects that enhanced, complemented, and blended well with an 18th-century structure.

As the 1950s drew to a close, Belair changed hands again; this time it was bought by developer William J. Levitt, who sold the old house to the City of Bowie for $1 in 1964; the building became Bowie City Hall for 14 years. As the 1980s began, Belair stood nearly derelict. The efforts of the City of Bowie and the Friends of Belair Estate combined to restore and turn Belair into a museum house, a tribute to over 300 years of local history and heritage. The mansion is open to the public on a regular basis.

Gov. Samuel Ogle, Belair's original owner, was born in northern England in 1694. Appointed provincial governor by Charles Calvert, fifth Baron Baltimore, Ogle arrived in Maryland in 1731, serving three nonconsecutive terms as Maryland's governor. He built Belair around 1745, bringing some of 18th-century America's most noted English Thoroughbred racing stock to the plantation for breeding. He died in Annapolis in 1752 and was laid to rest beneath St. Anne's Church there.

Anne Tasker Ogle, pictured here with her daughter Anne, was born in Annapolis in 1723, the daughter of Councilor Benjamin Tasker. Widowed at 29, Ogle raised three children, never remarrying. She died in 1817 and was laid to rest at Whitehall, the home of her daughter Mary Ogle Ridout.

The Ogle family crest dates from the time of the Norman invasion of England. The motto *Prenez en Gré* is translated as "Accept in Gratitude." The elk head atop the crest is featured in a number of pieces of surviving family silver.

Benjamin Ogle (1749–1809), the only surviving son of Samuel Ogle, inherited Belair despite a number of legal entanglements when he reached his majority. He and his wife, Henrietta Hill Ogle, maintained Belair as their country plantation, with their principal residence in Annapolis. Ogle served from 1798 to 1801 as the ninth governor of Maryland.

Belair Mansion, due to Ogle family kin and connections, enjoys an exceptionally rich history and heritage.

The Ogle family held Belair until 1871. After the Civil War, financial hardships of a former slave-driven tobacco economy took their toll on the Ogles and many others in Southern Maryland. For a period of 24 years, Belair had a succession of short-term owners. In 1895, it became the property of James T. Woodward, a New York banker and businessman born in Anne Arundel County, Maryland.

BELAIR THE RESIDENCE OF GOV SAMUEL OGLE

By the turn of the 20th century, James T. Woodward had begun a series of additions and improvements to Belair. The addition of a wing to the southeast side and rehabilitation of the structure created a lovely spot for Woodward, a lifelong bachelor, to entertain guests from New York and the local area. Among his first visitors were descendants of Samuel and Anne Tasker Ogle.

James T. Woodward was president of Hanover Bank in New York. He was the second child born to Henry Williams Woodward and Mary Edge Webb at Edgewood Plantation in Gambrills Station, Anne Arundel County, Maryland.

William Woodward became the master of Belair upon the death of his uncle James in 1910. William was a young banker who served in the diplomatic corps and became involved in Thoroughbred racing while in England. His passion for the sport came to fulfillment with his ownership of Belair and a major Thoroughbred dynasty. He followed Samuel Ogle's equine legacy by making Belair one of America's famous horse farms in the 20th century. In 1911 and 1912, Woodward added two wings to Belair, creating a five-part house comfortable for family, friends, and servants.

As a member of New York's Coaching Club, William Woodward and his friends enjoyed long coaching trips. Pictured here is their arrival, in 1916, at Belair's front door after a multiday trip from New York City. Their coach, the *Pioneer*, was pulled by four horses changed out at stops along the route.

Enlargements to Belair were designed by a New York architectural firm, Delano and Aldrich. Their commissions included Kykuit (the Rockefeller estate in Sleepy Hollow, New York), the Walters Art Gallery in Baltimore, the Japanese Embassy in Washington, DC, the American Embassy in Paris, and a host of other public buildings and numerous private homes.

During the Woodward ownership of Belair, the walls were lined with equine art, reflecting William Woodward's love of Thoroughbreds and racing. Foxhunting was also a particular favorite for Belair's residents. Dorothy Wintermere Pocurull, daughter of Belair's caretakers, is shown here in the sunroom, where William Woodward's collection of fox masques was displayed.

In 1957, after the death of William Woodward Jr., the family elected to sell Belair. William J. Levitt purchased Belair and sold the mansion to the City of Bowie for $1, mandating its use toward benefitting the community. Belair became Bowie's first formal city hall, functioning as such from 1964 to 1978.

As the city grew, creating a need for a larger municipal building, Belair declined. Stabilized and protected, the mansion nevertheless lingered in a sorry state. Realizing the historic value of the building, the City of Bowie elected to begin a restoration project, re-creating the elegance that had once been Belair. By the early 1980s, restoration of Belair had begun. With the support of the City of Bowie, tenacity of the Friends of Belair Estate, and assistance from the Maryland Historical Trust, long years of hard work took place. The goal of returning Belair to its former glory would take nearly 15 years to achieve.

The Belair Mansion officially opened as a museum in 1996 and is owned and operated by the City of Bowie. The gracious and graceful five-part structure exemplifies over 270 years of Maryland history and heritage and offers visitors a glimpse of two centuries of domestic use.

Today, the 1957 appearance of the Field Room has been re-created.

Based on rooms similar to the time period, the Study re-creates the mid-18th-century Ogle-Tasker presence at Belair. On the wall are 1750s prints done by the famous 18th-century artist William Hogarth. The table offers a relaxing game of cards.

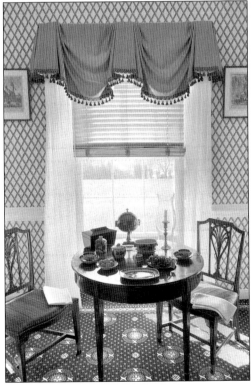

The re-created Sitting Room is pictured. The original gave early-19th-century ladies a spot to sip tea and gossip with friends.

Rosalie's Room is the chamber occupied by Rosalie Caroline Ogle, Belair's last Ogle resident. It reflects the time period of Rosalie's young womanhood in the mid-19th century.

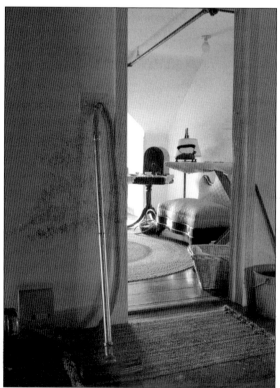

The Third Floor Maid's Quarters depict the living space of Woodward service staff in the 1930s.

Three

EQUINE HERITAGE

Bowie's long history so closely associated with the railroad is surpassed only by its longer association with the Thoroughbred horse and the "sport of kings," Thoroughbred racing.

Imported British Thoroughbreds (and other breeds) had raced in colonial America almost since the first colonists arrived. Maryland, Virginia, New York, and other colonies all enjoyed organized racing from the late 17th century. As the sport grew, so did the desire of gentry horse owners to field better horses. With this in mind, in the 1750s, Gov. Samuel Ogle and his brother-in-law, Col. Benjamin Tasker, imported three British horses to the Belair Stud with the specific intention of breeding a better, faster, stronger Maryland horse. Those three equines—Spark, Queen Mab, and the incomparable mare Selima—began a long tradition at Belair, in Maryland, and in the United States.

When William Woodward inherited the Belair farm in 1910, the passion for racing and breeding that was born in him as a teenager in New York came to full life. With an investment of $360 spent on a local stallion and three mares, Woodward revived the Belair Stud, elevating it to one of America's premier breeding and racing operations in the 20th century. While Woodward horses were actually bred in Kentucky, they were frequently at Belair for rest, recreation, and conditioning. Woodward felt that Belair's proximity to the Chesapeake Bay offered a superior training climate.

From the early 1920s through the mid-1950s, Belair Thoroughbreds were frequently in the winner's circle after many important races, including the Triple Crown series. In 1930, Belair's Gallant Fox captured the Triple Crown, and in 1935, his son, Omaha, replicated the feat. They are still the only sire and offspring to win the Triple Crown.

In 1914, the Southern Maryland Agricultural Association opened the Bowie Race Track. The track was frequented not only by locals but also by racing fans from up and down the East Coast. Special race trains, which used a spur line right at the track, brought visitors from Baltimore and points north. In 1958, "the track in the pines," as Bowie was often called, premiered winter racing in Maryland. Two weeks after the initial winter opening, a tremendous snowstorm stranded die-hard fans at the track, leading to the slogan "When It Snows, Bowie Goes."

Facing competition from other nearby tracks, lacking a turf course, and needing large repairs, Bowie Race Track closed on July 14, 1985.

IN MEMORY OF SELIMA

Selima, a daughter of the famed Godolphin Arabian, was imported to Belair by Col. Benjamin Tasker in the early 1750s. Her success as a racehorse and as a broodmare brought her great acclaim in the 18th century. This bronze plaque was commissioned by William Woodward in the 1930s. It hung for many years at the Belair Stable.

The Selima Stakes, held at Laurel Park Racetrack in Maryland, commemorates Selima's great racing legacy. Originally covering 1 1/16 miles (8.5 furlongs), the race today is run for 5.5 furlongs and is considered by some to be one of the most important races for juvenile (two-year-old) fillies.

Bowie Race Track opened in 1914, founded by the Southern Maryland Agricultural Association. The track was originally known as Prince George's Park. Fans filled the stands, some delivered by race trains run by the Washington, Baltimore & Annapolis Railroad and the Pennsylvania Railroad. Eighteen bookmakers handled betting. In the 1950s, after the grandstand was enclosed, Bowie became a pioneer in winter racing. The track closed in 1985, facing competition from other tracks on the East Coast.

COPYRIGHT 1927
CAUFIELD AND SHOOK, INC

GALLANT FOX
WINNER 1930 KENTUCKY DERBY

WOODWARD, OWNER

E. SANDE, JOCKE

A product of the famous stallion Sir Gallahad III and the incredible broodmare Marguerite, Gallant Fox was born, as were other Belair horses, at Claiborne Farm in Paris, Kentucky, in March 1927. William Woodward had a "special feeling" about the horse shortly after his birth. As a two-year-old, "the Fox of Belair" showed promise but immaturity. By the time of his three-year-old campaign, he had settled in. In 1930, the Preakness was run before the Kentucky Derby; he won by three-quarters of a length. The Derby, despite heavy rain, saw him defeat Gallant Knight by two lengths. The Belmont was no challenge—he finished three lengths in front of the second finisher. Gallant Fox is the only Triple Crown winner to sire a Triple Crown winner; his son Omaha replicated his feat in 1935.

William Woodward elected to retire Gallant Fox to stud after his 1930 season. Gallant Fox went on to have a 22-year career at stud, siring, among others, the 1935 Triple Crown winner, Omaha. Among his other offspring was Flares (a full brother to Omaha), who, in 1938, became the second American-bred horse to capture the Ascot Gold Cup. Gallant Fox died in 1954 and is laid to rest at Claiborne Farm, the place of his birth.

Omaha, foaled in March 1932, remains today the only Triple Crown winner sired by a Triple Crown winner. A handsome chestnut stallion standing over 16 hands, Omaha was not the favorite for the 1935 Derby win. He bested the competition by a length and a half. Going on to the Preakness, he beat the field by six lengths. At the Belmont, he bested his competition by six lengths once again.

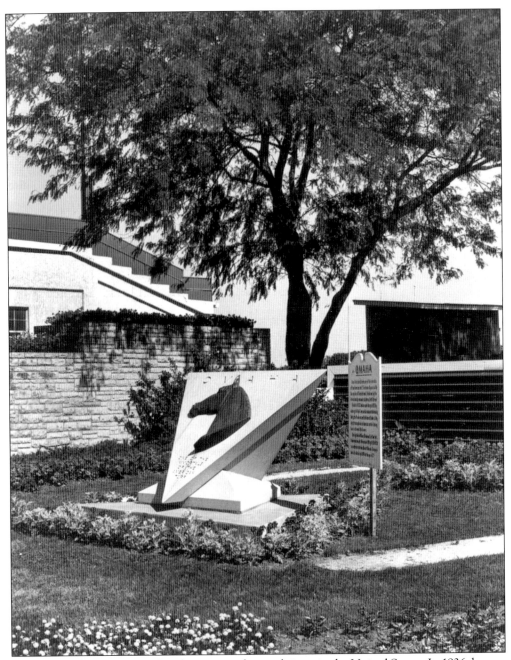

After his Triple Crown win, Omaha was raced several times in the United States. In 1936, he was shipped to England to compete in the Ascot Gold Cup. After several successes on British tracks, he came in second in the 1936 cup. While training for the same contest in 1937, Omaha came up lame and was shipped home; he never raced again. His performance at stud was mediocre. Eventually sold, he lived out the last years of his life in Nebraska and was buried near Ak-Sar-Ben Track in Nebraska at his death in 1957.

Belair's Johnstown is led into the winner's circle at the 1939 Belmont Stakes in New York. Hall-of-fame Thoroughbred Johnstown was foaled in 1936 at Claiborne Farm in Kentucky. Purchased from Arthur B. Hancock, owner of Claiborne, Johnstown carried Belair's silks to the winner's circle at both the Kentucky Derby and the Belmont Stakes in 1939. His defeat in the Preakness, depriving Belair of its third Triple Crown, was caused by a muddy track, something with which he had no experience. His daughter Segula was the dam of Belair's famous Nashua.

Fighting Fox, foaled in 1935, was a full brother to Gallant Fox. Fighting Fox competed in 35 races, winning first place in nine of them. Among his wins was the prestigious Wood Memorial Stakes in 1938.

The full glory of William Woodward's long breeding career likely came with the foaling of Nashua, a colt born in 1952. As a two-year-old, Nashua won six of his eight contests. As a three-year-old, he lost the Kentucky Derby to a horse called Swaps but went on to win the Preakness and the Belmont Stakes. His Derby loss to Swaps was vindicated by a race between the two in August 1955 at Arlington Park in Chicago. Nashua's racing career was brilliant: 22 wins, 4 places, 1 show. Upon his retirement, he took up residence at Spendthrift farm and became the sire of many excellent horses. His progeny continue to dominate racing today. Here, William Woodward Jr. and his wife, Ann, meet Nashua in the winner's circle of the 1955 Belmont Stakes.

James "Sunny Jim" Fitzsimmons (1874–1966) became trainer of Belair's American racing stock in 1923. Fitzsimmons was a legend. Among his other successful racers, he trained three Kentucky Derby winners, four Preakness Stakes winners, and six Belmont Stakes winners. He was racing's top money-winning trainer five times during his career. Sunny Jim continued to train Belair horses, including Nashua, until the sale of the Belair Farm.

This aerial view of Bowie Race Track, which was one mile long, gives a good perspective not only of the track itself but also of the attendance on winter race days, even in the snow! In 1958, a tremendous snowstorm stranded nearly 3,000 people, many of whom spent the night in the grandstand. The grandstand is to the left; barns for horses are to the right. The image also shows how little development had taken place in the Bowie vicinity prior to the purchase of Belair by William J. Levitt.

THE MISS MARYLAND STAKES
$15,000 ADDED
MOVITAVE
BOWIE FEB. 15, 1958

KNOLLWOOD STABLE-OWNER
J. BOWES BOND-TRAINER
5 1/2 FUR. 1:06

NICHOLAS SHUK
MILADY DARES
SEW IT UP

In a perfect example of Bowie's winter meet, Movitave won the 1958 Miss Maryland Stakes in the major snowstorm of 1958. The storm dumped over 14 inches of snow on the Washington, DC, area, but racing went on as planned at Bowie.

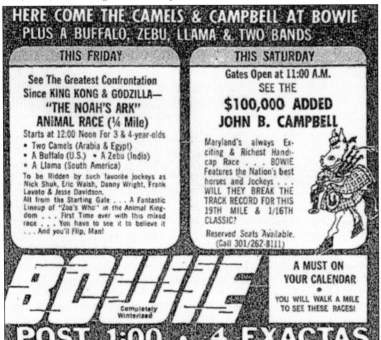

HERE COME THE CAMELS & CAMPBELL AT BOWIE
PLUS A BUFFALO, ZEBU, LLAMA & TWO BANDS

THIS FRIDAY

See The Greatest Confrontation Since KING KONG & GODZILLA—
"THE NOAH'S ARK"
ANIMAL RACE (¼ Mile)
Starts at 12:00 Noon For 3 & 4-year-olds
• Two Camels (Arabia & Egypt)
• A Buffalo (U.S.) • A Zebu (India)
• A Llama (South America)
To be Ridden by such favorite jockeys as Nick Shuk, Eric Walsh, Danny Wright, Frank Lavato & Jesse Davidson.
All from the Starting Gate . . . A Fantastic Lineup of "Zoo's Who" in the Animal Kingdom . . . First Time ever with this mixed race . . . You have to see it to believe it . . . And you'll Flip, Man!

THIS SATURDAY

Gates Open at 11:00 A.M.
SEE THE
$100,000 ADDED
JOHN B. CAMPBELL

Maryland's always Exciting & Richest Handicap Race . . . BOWIE Features the Nation's best horses and Jockeys . . . WILL THEY BREAK THE TRACK RECORD FOR THIS 19TH MILE & 1/16TH CLASSIC?

Reserved Seats Available.
(Call 301/262-8111)

A MUST ON
YOUR CALENDAR
•
YOU WILL WALK A MILE TO SEE THESE RACES!

BOWIE
Completely Winterized
POST 1:00 • 4 EXACTAS

Not only horses raced at Bowie. In 1972, the track hosted the Noah's Ark Race, featuring a camel, a buffalo, a llama, and a zebu (a breed of Indian cow). The camel had to be muzzled after it bit one track worker and broke a handler's arm. The zebu won the race. Feelings ran high that the camel, expected to win, had lost because he was muzzled.

The Bryan and O'Hara Trophy, now in the collection of the City of Bowie Museums, was named for James O'Hara and Gadsden Bryan, two businessmen who were responsible for the original construction of Bowie Race Track. The trophy was symbolically awarded to the winner of the Bryan and O'Hara Handicap, a stakes race honoring the two men. The massive silver trophy was made in England.

Bowie Race Track was frequently visited by celebrities and political figures, including actor Lorne Greene, the famous Ronald McDonald, J. Edgar Hoover, and Pres. Richard Nixon and his daughters Tricia and Julie. Pictured here are track general manager Al Karwacki (left) and noted newscaster David Brinkley.

With tote board results in the background, racing fans enjoy a day of excitement. At one point, the infield held a small lake. One day, track personnel arrived to find a small powerboat in the middle of the lake. Perpetrators of the prank were never discovered. The westward-facing stands helped to warm fans both inside and outside the clubhouse during the winter months.

In January 1966, a horrendous fire fanned by high winds of up to 50 miles per hour from a blizzard burned down five barns and killed 43 horses. The icy conditions caused a delay in emergency response. After a 30-minute trip to the track, firefighters arrived to find flames leaping into the air and total chaos on the site. One hundred horses were turned loose; some were found miles away from the track.

Four

BELAIR-AT-BOWIE

On October 17, 1961, the first residents took possession of their homes in the new development called Belair-at-Bowie, built by Levitt and Sons. The company had created similar successful Levittowns in New York (1947), Pennsylvania (1952), and New Jersey (1958). What brought Levitt and Sons to Bowie was the expansive highway and transportation system that linked Bowie to Washington, DC, and Baltimore. Bowie is located very near the Baltimore-Washington Parkway (completed in 1952), John Hanson Highway/US Route 50 (completed in 1957), and an interstate and local system of roads connecting many parts of the capital area.

Levitt and Sons planned a housing development that would be self-contained and affordable for middle-class families. Over the years since the company's inception, Levitt created an innovative assembly-line approach to the construction of residential units that reduced the time to build each unit and centralized the purchase of a home. The models to choose from were the Rancher or its larger version, the Devon; the Cape Cod; the three- or four-bedroom Colonial; and the Country Clubber. The developers incorporated many progressive elements of construction and amenities into their residential units, including extensive landscaping, air-conditioning, electrical appliances in the kitchen, and laundry rooms, which were not ordinarily available at the time at the prices offered by Levitt and Sons. The units were also characterized by their lack of basements, the exclusion of which allowed for speedier construction at less expense.

The planned community made space for places of worship, schools, and shopping centers. In addition to his assembly-line construction, Levitt was also a pioneer in what are known today as "walkable communities." But Levitt refused to sell to black families. The company only backed down on its racist policies and sold to black families after it was forced by the courts to do so. The company did not have control over resale of houses. A few African American families came to the community because the original owners sold their houses to them. In 1971, according to the *Bowie Blade-News* of September 22, three percent of the residents in Belair-at-Bowie were black.

The addition of shopping plazas, convenience stores, restaurants, service stations, retail businesses, commercial facilities, and amenities would complete the self-sustaining community envisioned by Levitt and Sons. In 1969, Collington Plaza opened along Route 301. The expansion of the Belair Shopping Center was completed in 1968. However, some commercial needs of residents of Belair-at-Bowie went unmet from the late 1960s to the early 1970s because the community was growing rapidly.

Over the years, the city of Bowie, with Belair-at-Bowie at its center, has cultivated a progressive attitude toward renewing and improving this suburban community with more commercial facilities and amenities for all residents. Belair-at-Bowie remains a tightly knit community in the center of Bowie today.

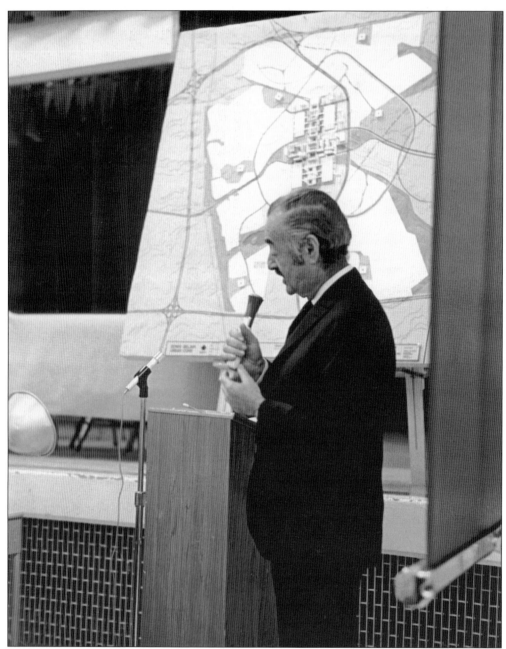

William J. Levitt, with his father and brother, was a principal builder of what has come to be recognized as the iconic American suburban community. Beginning in 1947 in Norfolk, Virginia, Levitt and Sons brought affordable housing to millions of post–World War II Americans, with developments small and large all over the United States, Canada, France, Spain, and Puerto Rico. Belair-at-Bowie was one of Levitt's largest developments. Levitt projects also included construction in Nigeria, Venezuela, and Iran. In this image, Levitt visited Bowie to promote his plans for a town center. The plan was complex, and perhaps rather forward-thinking in terms of suburban development. It included stores, restaurants and offices, townhouses, and an improved road system surrounding the development.

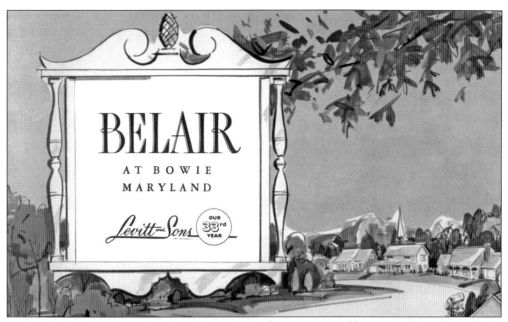

At the death of William Woodward Jr. in 1955, the executors of his estate elected to sell the Belair Stud Stable/Farm. In August 1957, Levitt and Sons purchased the property, including the Belair Mansion and Stable, for $1.75 million. In naming the new development Belair-at-Bowie, Levitt and Sons chose to acknowledge and honor the estate's long history and involvement in Thoroughbred racing.

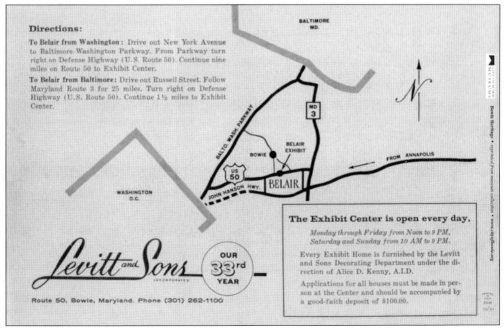

Directions:

To Belair from Washington: Drive out New York Avenue to Baltimore-Washington Parkway. From Parkway turn right on Defense Highway (U.S. Route 50). Continue nine miles on Route 50 to Exhibit Center.

To Belair from Baltimore: Drive out Russell Street. Follow Maryland Route 3 for 25 miles. Turn right on Defense Highway (U.S. Route 50). Continue 1½ miles to Exhibit Center.

The Exhibit Center is open every day,

Monday through Friday from Noon to 9 PM,
Saturday and Sunday from 10 AM to 9 PM.

Every Exhibit Home is furnished by the Levitt and Sons Decorating Department under the direction of Alice D. Kenny, A.I.D.

Applications for all houses must be made in person at the Center and should be accompanied by a good-faith deposit of $100.00.

Route 50, Bowie, Maryland. Phone (301) 262-1100

One of Levitt's strongest selling points for his new development at Belair was the proximity to both Baltimore and Washington, DC. Belair was a short drive from the Baltimore-Washington Parkway. The new John Hanson Highway (Highway 50) offered rapid access for residents employed by the federal government.

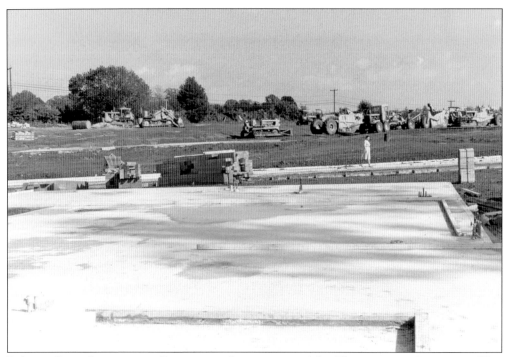

Belair-at-Bowie homes were all constructed on concrete slabs. There were no basements. This construction technique saved the cost of excavation and foundation concrete.

Numerous workmen had specific and directed tasks, right down to the painting of colors on a house. Precast sewer lines reduced time and labor for foundation preparation. Plumbers, painters, paper hangers, and electricians moved from one house to another installing bathrooms, kitchen appliances, paint, and wallpaper in an assembly-line mode.

Levitt purchased specific appliances by the thousands, assuring the lowest possible cost for them. Each house was constructed from a basic kit. Kits were delivered to each foundation slab and erected with incredible speed. When Levitt could not find enough lumber to suit him at a needed price, he purchased his own lumberyard.

Construction of Levitt homes was an assembly-line production. Historians today acknowledge that Levitt was to housing what Henry Ford was to the automobile. (Courtesy of Miller family photographs/Steve Miller.)

In 1957, at the sale of Belair Farm, the rolling fields and pastures that comprised the Belair Stud farm changed forever. The bucolic and well-loved Woodward Pond was quickly surrounded by the Levitt housing development.

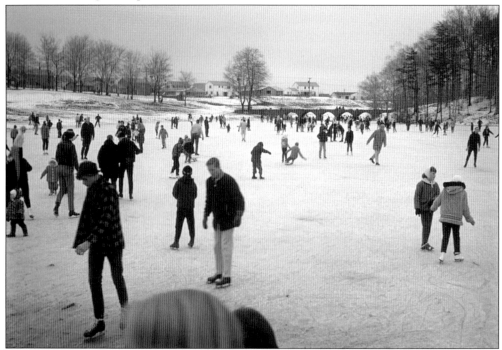

By the 1960s, Woodward Pond had been deeded by the Levitt Corporation to the Maryland–National Capital Park and Planning Commission and renamed Foxhill Pond in recognition of its location in the Foxhill section of Belair-at-Bowie. The iconic stone bridge constructed by the Woodward family in the early 20th century remains a picturesque feature of the pond. (Courtesy of Miller family photographs/Steve Miller.)

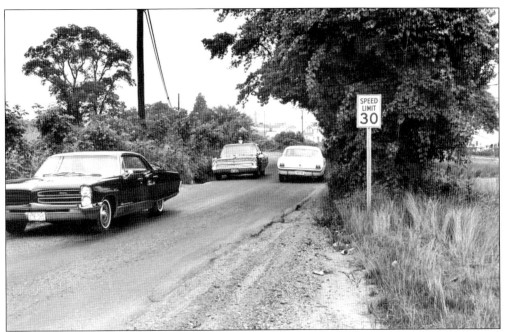

Belair-at-Bowie was developed in a very rural area dotted with small farms and the Belair Estate. Roads were not the multilane highways of the present. This image of Maryland Route 197 in early 1960s (known locally as Collington Road and Laurel-Bowie Road) illustrates the transportation issues that faced Belair's first settlers. Today, this stretch of Route 197 is a six-lane highway.

Belair-at-Bowie contained five different models; some were two-story Colonials, others were ranch-style homes. The Cape Cod boasted a large living room, a recreation room, and a laundry room with matching washer and dryer. The house had two bedrooms and a bath on the first floor, with two bedrooms and a full bath on the second floor. Each floor had a linen closet. The price for the Cape Cod was $15,990. It was Belair-at-Bowie's least expensive home.

THE ARDSLEY
Belair at Bowie

FIRST FLOOR PLAN

B.R.-2
8'-11 X 11'-6

BATH 1

T.V.

CLO

CLO

DINING ROOM
10'-0 X 10'-3

KIT
8'-6 X 10'-3

LIN

HTR

STORAGE
12'-0 X 8'-0

W. D.

CLO

CLO.

T.V.

LIVING ROOM
23'-0 X 14'-8

GARAGE
12'-0 X 23'-0

B.R.-1
12'-0 X 11'-4

PORCH

SECOND FLOOR PLAN

B.R.-4
9'-10 X 16'-0

BATH 2

LIN

CLO.

CLO.

B.R.-3
17'-0 X 17'-3

T.V.

room sizes shown are approximate

The diminutive exterior elevation of the Cape Cod model belied the spacious interior. Many residents divided the large second-floor bedroom into two rooms. Levitt advertising gave a sense of elegance to suburban homes. Homes were nestled on "grounds," surrounded by a landscape package that would be the envy of any homebuyer today. In 1964, Levitt formally named all models, and the Cape Cod became the Ardsley.

A Levitt advertisement in the *Washington Post* of January 1962 announces, "This House Wears Good Like a Domicile Should!" The price of the three-bedroom Colonial was $16,990, complete with "professionally landscaped grounds," two and a half baths, and a "delightful front porch." The advertising adds that the house "is completely air-conditioned by Westinghouse."

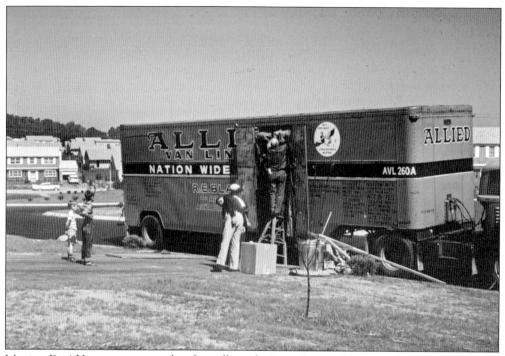

Moving Day! Houses were completed rapidly under Levitt's assembly-line process. Moving vans, sometimes a dozen a week, were a common sight in each section.

As young families moved in and grew, swing sets and play equipment sprouted all over backyards. Here, the Marks brothers, left and right, and Steve Miller, in the center, enjoy a sunny day in the backyard of Miller's new home. Jeffrey and David Marks's home is in the background. (Courtesy of Miller family photographs/ Steve Miller.)

The exploding population of the new community brought a need for neighborhood schools within walking distance of homes. The Somerset Section (Levitt communities were divided into sections) was the first to be settled and was the site of the first Belair-at-Bowie Elementary School. Between 1963 and 1970, ten schools opened in Bowie—five were dedicated in 1965.

The Levitt plan called for walkable communities. Places of worship, like schools, were constructed throughout the community. Before building an actual sanctuary or church, the members of the congregation used a couple of Levitt-built houses for worship and meetings. The photograph here shows a Christian Community Presbyterian Church meeting at the backyard of one such house, which stood next to the site where the present church was constructed on Belair Drive. (Courtesy of Miller family photographs/Steve Miller.)

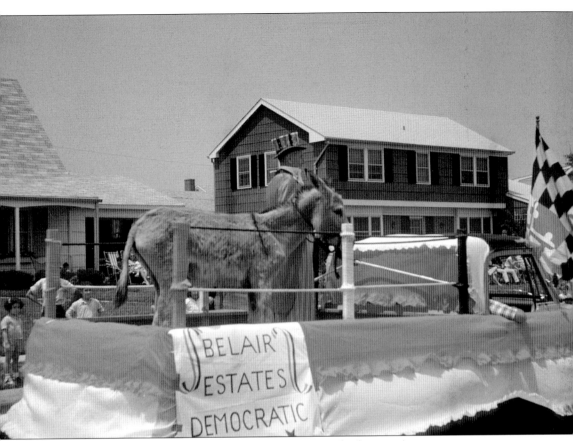

In the beginning, many viewed a move to Belair as a move to the frontier. As a consequence, a very tight, supportive community quickly developed. From the earliest days, parades and celebrations quickly became part of Belair-at-Bowie's community culture. Memorial Day parades, like the one shown here in the mid-1960s, were, and continue to be, important events in community life. (Courtesy of Miller family photographs/Steve Miller.)

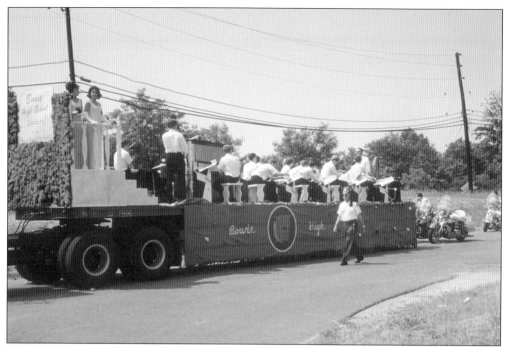

From 1967 through 1977, the Starliners, sponsored by Bowie High School, were a fixture in city events. The extremely popular group produced a number of record albums, including one titled *Bowie Straight Ahead*. Record sales funded travel to jazz festivals and competitions. (Courtesy of Miller family photographs/Steve Miller.)

This aerial view shows Belair and the Tulip Grove section of Belair-at-Bowie.

Five

HOUSES OF WORSHIP

On April 21, 1649, the Colony of Maryland passed An Act Concerning Religion, tolerating certain types of believers. Over the years, the concept of religious toleration came and went, in varying degrees, and Maryland has experienced religious diversity.

And so it is with the city of Bowie. In the 18th century, two major faiths—Roman Catholic and Anglican/Episcopalian—were dominant in the area. Sacred Heart Roman Catholic Church, a parish staffed by members of the Society of Jesus (Jesuits), was built in 1741. Several Anglican (Episcopalian) parishes appeared in the Bowie area: St. Barnabas, in Leeland, was established in 1704, when the Anglican Church became the established church of Maryland. Its first church was erected in 1709. The present church building dates from 1774. St. Thomas, in Croom, was first constructed in 1743–1745. St. Matthew's Catholic Church, a mission of Holy Family in nearby Woodmore, served many of the residents of the area, including workers at Belair Farm.

As time passed, Bowie's existing faith communities grew, and new communities added diversity.

Ascension Roman Catholic Church, near Huntington City, was dedicated in 1894. St. James Episcopal Chapel, in the heart of town, was built in 1906. Just west of Huntington, the First Lutheran Church of Bowie was constructed in 1907. A Methodist congregation met in various homes before construction of the Bowie United Methodist Church in 1884. Ross Methodist Church, built around 1909, served the African American community. Jewish families, lacking a temple or synagogue, worshipped in homes and stores.

With the development of Belair-at-Bowie in the 1960s, new churches of Christian denominations and two Jewish synagogues were added to the community of worshippers in Bowie. Many of those sites are, by Levitt master planning, nestled in the midst of Belair's residential neighborhoods, allowing people to walk to worship.

Today, many faiths are represented within the city of Bowie and the greater Bowie community. The photographs in this chapter depict the early places of worship in Bowie. New churches, congregations, synagogues, and temples blend with old, working together for a shared purpose.

Sacred Heart Chapel in Whitemarsh Parish stands on land given to the Society of Jesus (Jesuits) by members of the Carroll family, one of 18th-century Maryland's prominent Roman Catholic families. The Jesuits who staffed Sacred Heart acted as missionaries to other locations throughout Maryland. Known in its earliest days as the Mission of St. Francis Borgia, the structure standing today incorporates part of a building constructed around 1741. The chapel is still in use, but most modern services are held in a new church constructed just below the chapel.

In 1789, Roman Catholic clergy met at Sacred Heart/Whitemarsh to elect John Carroll, a native of Upper Marlboro, as the first bishop of the Roman Catholic Church in America. Today, the sanctuary and sacristy from the original church still exist, having survived a fire in 1853 that destroyed the rest of the building. The burned sections of the church were rebuilt in 1854, with further restoration in 1874. (Courtesy of Sacred Heart Church, Jack Blevins, photographer.)

The Shrine of the Blessed Virgin was built at Sacred Heart in 1856, commemorating the 1854 apparition in France of Our Lady of Lourdes. In the 19th century, the shrine became a popular site for religious pilgrimages from Washington, DC, and Baltimore. One such pilgrimage, in 1874, drew over 3,000 worshippers. Worshippers took the Baltimore & Potomac Railroad to Collington Station, about two miles from Sacred Heart, and walked from there in procession to the shrine. Over the years, the shrine fell into disuse, but it was restored in 1957. (Courtesy of Sacred Heart Church, Jack Blevins, photographer.)

Built in 1774, the present St. Barnabas Episcopal Church, the third church on the site, was the place of worship for Anglicans in the Collington (South Bowie) area in the 18th century. This photograph, taken in 1939, offers a glimpse of the structure's classic architectural style. Furnishings in the church—the original 1718 baptismal font and silver communion service and a 1721 painting of the Last Supper by Gustavus Hesselius—reflect the structure's long use as an Anglican/ Episcopalian house of worship. (Courtesy of the Prince George's County Historical Society.)

Perkins Chapel, built in the 1860s, is located in Glenn Dale, close to Bowie. One of the few surviving rural chapels in the area, it was, in the earliest days of Huntington/ Bowie, the place of worship for a small group of Methodists prior to the construction of the First Methodist Church. Its cemetery contains graves dating to 1871.

Pictured is the First Methodist Church. Organized Methodism began in Bowie in 1874. Initially a small congregation of nine or 10 people, the group met in various homes, including the Straining House. An 1880 donation of land enabled the congregation to construct a church building in 1884 at a cost of approximately $1,000.

In order to serve Roman Catholics on the west side of early Bowie, permission was granted by James Cardinal Gibbons for the Society of Jesus to construct a second parish. The Church of the Ascension was dedicated on September 9, 1894. Sacred Heart became a mission of Ascension. For many years, all residents heard the tower bell toll at 6:00 a.m., noon, and 6:00 p.m.

The interior of the Church of the Ascension is pictured here. Ascension's beautiful Gothic Revival structure was destroyed by fire in 1977. The church was rebuilt and dedicated in 1986. The altarpiece in this image from the early 20th century, showing the ascension of Christ into Heaven, still exists. Today, the mural has been divided and flanks the sides of a magnificent stained-glass window.

St. James Episcopal Chapel was originally established as the Bowie Mission. Beginning in 1896, Sunday school meetings were held in the home of Nannie Cornelious. Like the First Methodist Church, the congregants of the mission met in the Straining House until the chapel was constructed by local builders John and Millard Schafer. The cornerstone was placed on September 2, 1906. For many years, St. James remained a mission of Holy Trinity Parish in Glenn Dale. St. James closed in 2010.

The altar at St. James held special significance for members of the parish. It was designed and built by cabinetmaker Albert Smith, a member of the parish who fashioned it from a chestnut tree that grew in Bowie. Smith built the altar in memory of his children who had died in infancy. (Courtesy of Fannie L. Basim.)

At the closing of St. James in 2010, the altar was moved, and it remains in use in St. James Chapel at nearby Holy Trinity Episcopal Day School. (Courtesy of Fannie L. Basim.)

Bowie's African American Methodist community formed prior to 1909 and met for services in Frank Luers's hardware store on Eleventh Street. Worshippers carried benches into the store every Sunday for services. Construction of the church building was facilitated by the church sisterhood. Through their efforts, the church was built with lumber purchased from a dealer who deferred payment until the congregation, lacking a building fund, could accumulate sufficient funds. The cornerstone for Ross Church was laid in 1913.

Bowie M. E. Sunday School
June 30, 1912; 3,4,5 ...

Pictured is the Bowie Methodist Episcopal Sunday School; young students are lined up for a group picture in June 1912. For many years, the congregation was without an assigned minister. Services were conducted by a preacher from the Bladensburg Circuit. In the absence of an ordained minister, men from the congregation officiated at Sunday services.

During the late 19th and early 20th centuries, the Episcopal congregation held services and Sunday school in the Peach House, which was built in 1777 and was affectionately known as "the Old Relic." It stood near the corner of Sixth and Maple Streets in Huntington. It was removed to allow construction of the Bowie Methodist Church.

St. Matthew's Chapel was a mission of Holy Family Catholic Church in nearby Woodmore. The chapel's first mass was celebrated on Christmas Day, 1943. Both parishes were staffed by the St. Joseph Society of the Sacred Heart (Josephites), whose mission is to serve the African American community. A number of workers on Belair Farm worshipped at St. Matthew's. Today, the church has been deconsecrated and repurposed as the home of the Collington Lodge of the Masonic Order. (Courtesy of Holy Family Catholic Church.)

St. Matthew's students are pictured here. St. Matthew's remained a mission of Holy Family until 1957. The congregation was served by a large catechetical center, used for instructing children in the Catholic faith, that sat 150. At its close, the property reverted to its original owners, the Sprigg family. (Courtesy of Holy Family Catholic Church.)

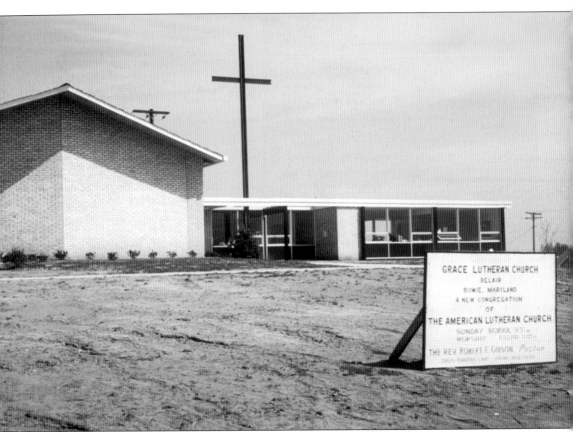

With the construction of Belair-at-Bowie, a building program of houses of worship began alongside the building of homes. Grace Lutheran Church, which had a charter membership of 149, opened on January 6, 1963. It is located on Belair Drive in the midst of residential Belair-at-Bowie.

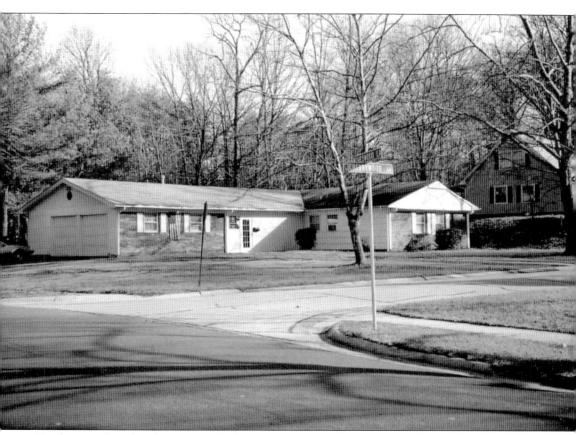

Two houses of worship for Bowie's Jewish community were constructed during the development of Belair-at-Bowie. Nevey Shalom, now closed, was founded in 1962. Temple Solel, pictured here, began in 1963, when the congregation purchased a Levitt ranch-style house. The house was subsequently sold to a Christian church. (Courtesy of Temple Solel/Rabbi Steve Weisman.)

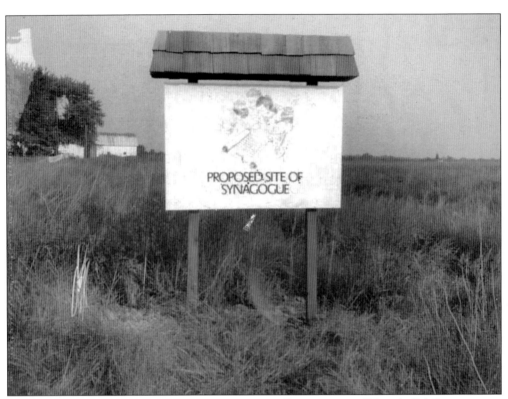

Construction of Temple Solel's present structure began in 1971 on a plot of land in what was, at the time, rural Mitchellville in South Bowie. Much of the work in the interior of the building was completed by members. Temple Solel was dedicated in 1974 and remains a vibrant Reform Jewish community today. (Courtesy of Temple Solel/Rabbi Steve Weisman.)

The nearly completed original structure of Temple Solel is pictured in 1972 on Mitchellville Road. A sukkah is being constructed in the foreground. (Courtesy of Temple Solel/Rabbi Steve Weisman.)

Six

SCHOOLS

Education has been, since the beginning of Bowie's life as Huntington, an important facet of its municipal and domestic life. Schools were among the earliest buildings constructed in the new town.

Public education in Maryland began after the Civil War. Schools were racially segregated throughout the state. Separate but not always equal, schools for both black and white children were established and were among the earliest community-focused buildings erected.

By the late 1870s, white children could attend Cedar Grove School, just north of Huntington City. By 1877, Cedar Grove was joined by Horsepen Hill School, built to educate black children. Erected in the eastern part of the city, the structure was used until the late 1920s, when the Tenth Street School was built. Later additions included a school at Thirteenth Street and Chestnut Avenue, Eighth Street School, and Duckettsville School.

Beginning in 1917, approximately 5,000 schools were constructed in 15 Southern states dedicated to the education of African American children. The schools were partially funded by Chicago philanthropist Julius Rosenwald, president of Sears, Roebuck and Company. Communities were encouraged to apply to the Julius Rosenwald Fund, which would then contribute a portion of the construction cost, with the local jurisdiction required to operate and maintain the school. The new Rosenwald Schools were a vast improvement over existing rural black schools and were considered state-of-the-art in educational improvements. In the later years of the Rosenwald School Program (after 1928), the fund also supported postsecondary schools and teacher preparation. Prince George's County was the home of 27 Rosenwald Schools, five of which (Duckettsville, Fletchertown, Bowie, Collington, and Mitchellville) were located in the Bowie area. Today, only the Collington Rosenwald School still stands in Bowie.

In 1945, the Eighth Street School closed to high school students. Bladensburg and Laurel High Schools were used to educate students from Bowie. In 1965, today's Bowie High School was opened.

In 1914, higher education came to Bowie. The Baltimore Association for the Moral and Educational Improvement of Colored People opened in Baltimore in 1865. That school was reorganized in 1893 to become a normal school dedicated to the education of black teachers. By 1914, the school had moved to Bowie and was operating as the Maryland Normal and Industrial School. Eventually expanding to a four-year program, the school became Bowie State College and, in 1988, Bowie State University. Bowie State University, part of the University of Maryland System, is one of the 10 oldest African American institutions of higher education in the country and is Maryland's oldest historically black university.

Bowie Schools educated black and white students in segregated schools before the practice was abandoned. This picture of the student body at Bowie School on Eighth Street taken around 1930 includes a young Carlyle "Jiggs" Lancaster (second row, left). Lancaster grew up to become a noted attorney and was the attorney present when Huntington City/Bowie annexed the Levitt development of Belair-at-Bowie.

Eighth Street School, built in 1911–1912, opened for students in the fall of 1912. It was originally a four-room elementary school, and some high school classes were added in 1923, when ninth-grade diplomas were awarded. By 1927, a full four-year course of study was in place. Additions in 1928 and 1940 enlarged the high school section, allowing the addition of another teacher and commercial classes.

In a later view of Eighth Street School, the expansion (which was to the rear) is not evident, but this photograph shows the entire student body from primary grades through high school. Restored in the mid-1990s, the historic school remains in use today as the Huntington Community Center.

Duckettsville was School No. 3 in District 14. The first teacher was Louise Green. An early review of the school states: "We fear that we can say little but words of praise for this brand-new Rosenwald School with its neat cloak room, clean floor, tidy window curtains, enthusiastic children." The report does cite the fact that the teacher needed a teacher's desk and chair and a bookcase.

Teachers Florence Williams and William Culver are pictured with students from Horsepen Elementary School, one of Bowie's Rosenwald Schools. Prior to the 1920s, in addition to African American children from the Huntington area, children from the nearby village of Fletchertown traveled to Bowie to attend Horsepen Hill School.

Shown in the late 20th century, Fletchertown School was a one-room Rosenwald School that served as many as 50 students at a time from primary through seventh grades. Sold in 1952 for $1,200, the school was converted to a private residence, but it has since been demolished. (Courtesy of Susan G. Pearl.)

Built in 1916, the D.S.S. Goodloe house was owned by Don S.S. Goodloe, the first principal of the Maryland Normal School, now Bowie State University. A prominent example of Colonial Revival style, it was designed by African American architect John A. Moore. The building continues to be owned by the university and is an important African American landmark in Bowie and in Prince George's County. (Courtesy of Huntington Heritage Society–Mills Collection.)

Collington School was built in 1926–1927 at a cost of $5,300. The Rosenwald Fund provided $700 toward its construction. Collington was a two-teacher school. The building still stands. It has been converted to a private residence.

The Tenth Street School, pictured here in the 1950s, was built in 1927 under the Rosenwald Schools program. It consisted of two classrooms and two cloakrooms. When no longer in use, it was converted to a residence.

State Teachers College-Bowie, Md. Beginners Class in Session - 1938

As part of teacher training, the Maryland Normal and Industrial School was the location of a model school for small children. Classes were held at the B.K. Bruce Building, named for the first African American to serve a full term as a US senator. The model school enjoyed an excellent reputation for many years. This image of students is dated 1938. Students were supplied with books and materials not available to children in rural black schools. (Courtesy of the University Archives and Special Collections Department, Thurgood Marshall Library, Bowie State University.)

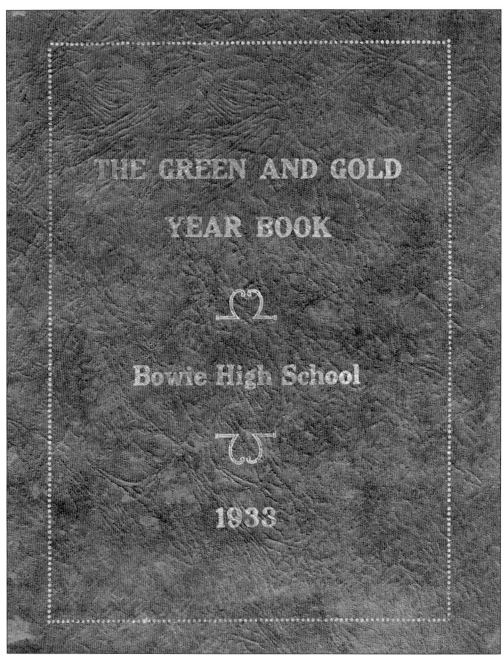

THE GREEN AND GOLD

YEAR BOOK

Bowie High School

1933

The Bowie High School class of 1933 published a 12-page yearbook highlighting the senior class of 10 students. Favorite quotes, a class history and prophecy, and a class will are included in the publication. Amongst the legacies to the junior class were chewing gum, used and unused; a "much used compact"; and one student's supply of ink. A sense of humor and camaraderie, which would carry these students through the coming of World War II, was very strong. (Courtesy of Fannie L. Basim.)

In 1930, seventeen students entered the class of 1934. Students studied civics, English, science, and algebra. They presented a class musical offering a trip around the world. By graduation, the world of the class of 1934 was much smaller. Five students graduated in the class, all young women. Their senior production was a play entitled *Small Town Romeo*.

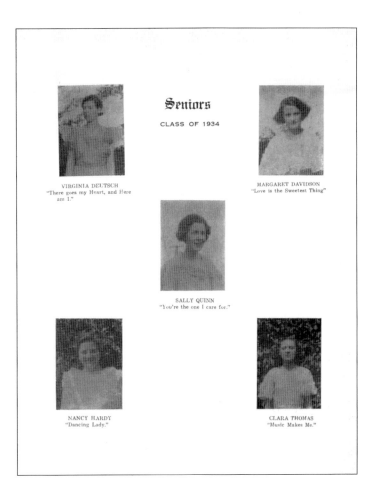

Seniors

CLASS OF 1934

VIRGINIA DELTSCH
"There goes my Heart, and Here am I."

MARGARET DAVIDSON
"Love is the Sweetest Thing"

SALLY QUINN
"You're the one I care for."

NANCY HARDY
"Dancing Lady."

CLARA THOMAS
"Music Makes Me."

In 2015, Bowie State University celebrated its 150th anniversary. Today's campus is vastly different and much larger than the one seen in this 1936 image. Bowie's student body now numbers over 5,600 students. The university, whose early focus was on teacher education, became a liberal arts institution in 1963. Bowie State University now offers 22 different undergraduate majors and 38 master's, doctoral, and advanced certificate programs.

Pictured here is Bowie State's 1928 football team. Intercollegiate sports began early at Bowie, and today they remain an important part of campus life. Bowie State University's homecoming celebrations continue to commemorate college leaders past and present, campus life, and fellowship. (Courtesy of Huntington Heritage Society–Mills Collection.)

Seven

BUSINESSES

Eighteenth-century Collington consisted of small tobacco farms scattered across the area. While there were undoubtedly itinerant peddlers on those small plantations, there were merchants operating small stores as well. The greatest evidence of those businesses and mercantile activities, however, was in areas like Upper Marlboro, Bladensburg, and Annapolis, not in Collington.

The coming of the railroad in the later 19th century and the establishment of Huntington City changed that.

In Huntington, the tourism industry was among the early commercial enterprises. Shortly after the first residents arrived, John G. Seitz opened the Bowie House Hotel. Three general stores, owned by Bernard Luers, Lemuel Porter, and John Straining, served the needs of the citizens. Luers also operated a shoemaker's shop in his store.

The streets were lined with shoemakers, blacksmiths, barbers, and by 1896, a liquor store. Many of the buildings were destroyed in the horrific fire of 1910, but others survived into the later 20th century. Several, like Brady's Store in the Highbridge section, Schneider's Store on Route 450, and Edlavitch's Store in Mitchellville, were outside the limits of Huntington, serving the needs of those not living in town. By 1927, Bowie's first automobile dealer, Bowie Motor Company, had joined the other merchants in town, and of course, with the advent of the motorcar, a number of garages opened as well.

Beyond Huntington/Bowie, the area (then still referred to as Collington) remained largely agricultural. Belair Farm, the property of William Woodward and likely the largest farm in the area, functioned not only as Thoroughbred farm but as a full agricultural operation.

With the arrival of Belair-at-Bowie, shopping opportunities exploded to the south of Huntington. In his plan for community developments, William J. Levitt set aside land for shopping centers. Soon, modern shopping centers such as Hilltop Plaza, the Marketplace, and Freestate Mall offered retail services in Bowie. The construction of modern homes created a need for service businesses such as heating contractors, plumbers, appliance repair, and hardware stores.

Built around 1870 by Samuel Domer, Edlavitch's Store also housed a bar, billiard room, blacksmith, and barbershop. It served the needs of the residents of South Bowie for many years. The Edlavitch family, Russian Jews who immigrated to the area in 1888, purchased the store in 1895. It was destroyed by fire in 1985.

Joffe's Store, restored and known today as Fabian House, was built around 1896 for Simon Joffe. The family lived in the rear of the building and in the addition to the left. At the time of his death in 1917, the store inventory included "150 lbs. of coffee @ 10¢ a lb., 1,000 pairs of shoes, ranging in price from 50¢ to $1.60 per pair, 37 boxes of ladies underwear at 75¢ per box," washtubs, saws, roofing materials, and children's rubber boots.

Charles Fladung's Blacksmith Shop provided hardware, horseshoes, and iron objects used by local residents. Martin Fladung also carried on the wheelwright's trade in the shop, providing wheels for carriages and wagons. William Woodward, owner of the Belair Farm, was among the customers served by the Fladungs.

Hermine Johnston's well-stocked general store was on Tenth Street, just east of the old railroad bridge. She also offered her services as a midwife and caregiver. As with many original residents of the town, her descendants still live nearby.

In 1910, train travelers and locals could quench their thirsts at Bob Smith's Hotel barroom. The hotel stood in the area behind today's railroad museum. Like many of Huntington City's commercial buildings, Smith's hotel faced the railroad tracks.

In its earliest days, Huntington City's post office was located in various stores. Communication by post was critical in the beginning—telephones came to the area in 1906. In the early 1930s, a new post office was constructed. The building remains in use today as the Old Bowie Area Post Office.

In addition to crops like tobacco and corn, the Belair Farm raised Shropshire sheep, shorthorn cattle, and hogs. From around 1916, William Woodward also bred champion Clydesdale horses. A Mr. Davidson, one of the farm managers, is shown here on the right receiving an award for the pictured horse.

During World War I, the Belair Farm contributed to the war effort by sending a number of sheep from the farm's flock to the White House to graze the lawn at the request of President Wilson. The sheep saved manpower, freeing groundskeepers to join the Army. When sheared, the 48 sheep earned $52,823 for the Red Cross through an auction of their wool.

The Bank of Bowie opened for business in 1920. Several years later, the structure shown here was erected. It was the scene of an attempted burglary by the Tri-State Gang, who broke in and attempted to open the vault with an acetylene torch, setting fire to a rug. The gang members fled when the fire started. The blaze was observed by a resident, who reported the fire the next day; it was then that the burglary attempt was discovered.

The Bowie Building Association was founded in 1926. While the original incorporators hailed from other parts of Prince George's County, the original board of directors was comprised of residents of Bowie. Today, the structure houses the Old Town Bowie Welcome Center and Museum.

WINE A GOOD DANCE FLOOR BEER

MEATS PHONE BOWIE EXCHANGE GROCERIES

JOE SCHNEIDER'S FARM AND STORE

AT COLLINGTON BRIDGE, 10 MILES FROM PEACE CROSS

Outdoor Grill For Oyster And Weinie Roasts

Night Horseback Riding Good Bridle Paths
By Electric Lights For Daytime

WE CATER TO PRIVATE PARTIES

Schneider's Store not only sold food and goods, but it was also a place for social gatherings. Nearby residents recall opening their windows to hear music from Schneider's jukebox, one of the first in the area.

The Bowie Merchandise Corporation, Ltd., also known as the Community Store, opened in 1915, making it one of the earliest co-op endeavors in the local area. The store was not successful, however, and closed in a few years.

The Odd Fellows Hall, built in 1932, was the home of Bowie's first movie theater. A local band, the Rhythm Makers, played for monthly dances at the hall. The hall was used for cooking classes when power and electric stoves came to Bowie. Over the years, the building saw many different uses. It is still in use today as a restaurant.

Until the Levitt Corporation purchased Belair Estate in 1957, the Bowie area remained largely agricultural. Here, the Allen family cuts and spears tobacco on their large farm in Mitchellville/ South Bowie. Today, the former Allen farm is a City of Bowie park called Allen Pond.

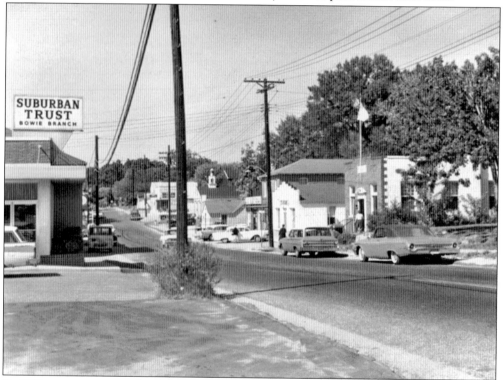

By 1958, a newer, more modern bank building had been constructed at Ninth Street and Railroad Avenue. The Bank of Bowie, after several name changes, merged with a large local bank, Suburban Trust. Visible in this image, on the right, is the 1930s post office. The firehouse bell can be seen in the center of the photograph.

The development of Belair-at-Bowie in the early 1960s brought an influx of new residents to the area south of Huntington/Bowie. Almost immediately, shopping centers like the Marketplace sprang up, serving the suburban demand. Tommy the Turtle, pictured here, stood in the middle of the Marketplace and quickly became not only a favorite of very young shoppers but also an iconic object for anyone growing up in Belair. Local residents still fondly remember climbing on Tommy while parents shopped. (Courtesy of Mike Rauck, the Westcott Collection.)

Suburban development at Belair demanded a different type of grocery store/market than those already present in Bowie. Safeway Stores began building new Bowie stores in the 1960s. After the arrival of larger chains, a few of the local grocery stores remained open for a while, but the era of small grocery stores in Bowie drew to an end. (Courtesy of Safeway, Inc.)

By April 1966, Belair-at-Bowie had its own theater on Superior Lane. Originally called Wineland's Belair Cinema, the theater opened with one screen. The first feature shown was *The Singing Nun*, with favors offered "for Ladies and Children." The theater also hosted special Children's Film Festivals. (Courtesy of Mike Rauck, the Westcott Collection.)

Eight

PEOPLE AND PLACES

Since the 1870s, the city of Bowie, whether called Huntington, Collington, or Mitchellville, has been a hometown, a homeplace. As with many hometowns, Bowie has grown and developed from a small railroad community surrounded by farms to a bustling suburban development to one of the largest cities in Maryland. But the essence of this hometown remains in the people and places that have made and continue to make Bowie the place it is.

Generations of people have been born here and have lived, worked, and died here. Some have gone to fight wars. Some have gone to big cities. Some have achieved fame and fortune. And some have continued to live quiet lives in this beloved hometown. Many have returned, finding a safe and secure environment in a close-knit, friendly place.

Special places, both sacred and secular, have remained over the years. Some have changed. Many of those who peopled those places have gone, but their contributions to the history of the city remain. Men and women like Dr. George Lancaster and Fannie Johnson contributed to a community that still holds their memory close. The legacy of multimillionaire developer William J. Levitt is still strong in the streets and courts of Belair-at-Bowie.

While many of the same places of worship remain, new ones now welcome worshippers. Generations of Bowie citizens have visited parks and ponds that have long been a part of the community. Education for children of all races continues to be of paramount importance in Bowie, as it has been since the early 1900s.

Small general stores have been replaced by larger shopping venues, but a new town center mall reflects the "vintage" aura of the past. New houses have been erected on former tobacco fields. Narrow roads have been replaced with four-lane highways, but most importantly, all roads still lead home!

Thomas Lancaster Lansdale was born in 1748 in Queen Anne District (what is now Bowie). He served with distinction in the Revolutionary War and was an original member of the Society of the Cincinnati, a patriotic organization of commissioned Revolutionary War officers who served under Gen. George Washington's command. Lansdale died in 1803, and while the reasons for the location of Lansdale's grave remain unknown, his remains rest in a small City of Bowie park, honoring his service as one of the area's distinguished veterans in the American Revolution.

Anna Maria Cooke Ogle (1777–1856) was the wife of Benjamin Ogle II. Anna Maria, one of nine children, was the mother of 14 children. She and her husband were the first Ogles to use Belair as their sole residence. She and her mother-in-law, who were cousins, shared the same name. Anna Maria Ogle rests today, with other family members, in a small cemetery behind Belair Mansion.

Born in 1817, Dr. George Cooke Ogle was the son of Benjamin and Anna Maria Cooke Ogle. Mired in a sea of debt after the Civil War, Dr. Ogle (who resided in Baltimore) defaulted on several mortgages held by his Virginia cousins and was forced to sell Belair, ending over 125 years of family ownership of the plantation.

James Brady was born in Highbridge, near Huntington City. After a disastrous fire at a barn at Belair, William Woodward became concerned about the safety of horses lodged at Belair Stable. Woodward refinished the southern side of the stable, turning a part of it into a small apartment. Brady was asked to be Belair's first stable master, with the apartment as his quarters. His family—his wife, Gertrude, and their children, Thelma and James—were the first human residents of Belair Stable.

The Thomas brothers—Henry, Paul, and Charles—were workers at the Belair Farm from the 1920s through the 1950s. They were employed as gardeners, chauffeurs, and most importantly, handlers for Belair's valuable Thoroughbred horses. Charles is pictured here at Belair Stable with William Woodward's 1938 Buick Century.

Immigrants from Great Britain, Edward and Helen Wintermere were caretakers at Belair from the mid-1930s until 1957, raising their daughter, Dorothy, in an apartment in the southeast wing of Belair Mansion. At the Woodward sale of Belair Farm, the Wintermeres retired to Florida, but their descendants continue to live in Bowie today.

Fannie Johnson was born in 1885 and died in 1958. She worked for families in Huntington/Bowie for many years. Amongst her skills was midwifery; she delivered many babies throughout town.

Dr. George E. Lancaster moved to Bowie as a child; his father, Edward, was a baggage master for the Pennsylvania Railroad at Bowie Station. After attending Loyola University School of Medicine, he served in World War I. After marrying, he returned to Bowie with his wife, Jewell, and raised four children. House calls were first made from a horse and buggy, but he later acquired a Ford Model T. Dr. Lancaster made calls to local farms and to the Belair Mansion and also served the Bowie Race Course. Often, during the Depression, he was paid with chickens, eggs, and farm produce. In addition to possessing his own livestock, Dr. Lancaster was also a beekeeper.

Don Speed Smith Goodloe was the first principal of the Maryland Normal and Industrial School at Bowie. He served from 1911 (when the school relocated to and opened at Bowie) until 1921. (Courtesy of the University Archives and Special Collections Department, Thurgood Marshall Library, Bowie State University.)

The Szabo family, European immigrants to the area, worked on the Belair Farm, residing in the Gate House near the entrance to the estate. Georg and Anton Szabo were the estate's gardeners.

Founded in 1875, the Girls Friendly Society is a group associated with the Episcopal Church. Its goal is to unite women and girls of all ages, races, and faiths in friendship, recreation, and fellowship. St. James Church in Huntington sponsored a local group, pictured here. Members held bazaars, fashion shows, pet shows, and plays as fundraisers for good causes in the local area.

Pictured is Bowie's first baseball team. Sandlot baseball was a popular pastime from Huntington/ Bowie's earliest days. Groups from churches and neighborhoods held contests throughout the summer. The Zug family farm held a baseball field, accessed by a route through a swamp, woods, and field. Residents knew when the local team was victorious: tradition called for a volley of vehicle horns all the way through the woods upon leaving the field. Bowie's baseball heritage is long and rich. Blacksox Park, a 70-acre park in the southern part of Bowie (Mitchellville), was the home of the Mitchellville Tigers and the Washington Black Sox. From the 1930s through the early 1970s, teams like the Tigers and the Negro League's professionals, the Homestead Grays, created a baseball legacy in Bowie continued today by the Bowie Baysox, the Eastern League AA affiliate of the Baltimore Orioles.

As part of the purchase of the Belair Estate, Levitt and Sons acquired the historic Belair Mansion and Stable. After brief using it as office space, Levitt deeded the mansion to the city for $1, with the proviso that it should be used in perpetuity for municipal purposes beneficial to the citizens of the city. Here, Bowie mayor Frank Wilson receives the mansion keys from James Lee, representing Levitt and Sons. Belair would serve as city hall from 1964 to 1978.

In 1964, Belair Mansion became Bowie's first formal city hall. Gov. Millard Tawes, in the center, is welcomed to the mansion by Mayor Frank Wilson, on the right.

A smiling Elsie Woodward (wife of William Woodward) makes her way at Elmont Park, home of the Belmont Stakes, after watching Belair Stud's Omaha take the Belmont, making him the Triple Crown winner for 1935. The "mistress of Belair" was well known for her hospitality at Belair and the other Woodward homes. After the deaths of her husband and son, she remained active in Thoroughbred racing—fielding, in partnership with her daughter Edith Woodward Bancroft, the famous Damascus, winner of both the Preakness and Belmont Stakes in 1967.

Veterans Park, near historic Old Bowie, honors all Bowie veterans from all wars. The park features a memorial to the residents of Bowie who have served in the military during armed conflict and those who have given their lives in service to their country.

Foxhill or Woodward Pond may be one of Bowie's most iconic places. Part of Belair Farm, the brownstone bridge over the pond was constructed by the Woodward family during estate improvements in the 1920s. Created by damming a stream from Collington Branch, the pond has been a recreational site for Bowie residents. The pond provided ice to the Woodward farmworkers and likely even the Ogle family in the 18th and 19th centuries. In the 20th century, it has provided opportunities for fishing, boating, strolling, and ice-skating.

Originally owned by the Allen family, the Allen Farm, which included a large pond, was a typical county farm. The Allens grew tobacco and raised cattle there. James Allen stocked the pond for fishing; with a small investment for an annual share, members of the public could fish. In 1965, Allen sold the farm acreage to Levitt and Sons with a request that the land become a community park.

Today, Allen Pond Park is the crown jewel of Bowie's 14 city parks. Its 85 acres include walking paths, an ice arena, a skate park, picnic pavilions, play areas, sports fields, and an amphitheater. James Allen would be pleased to know that the 10-acre pond is still stocked and is available for fishing.

Built in the early 19th century, Willow Grove Plantation stood just outside modern Bowie's boundaries. Built by members of the Bowie family, Willow Grove was the home of Walter "Wat" Bowie, a member of the Civil War–era Mosby's Rangers and a notorious Confederate spy. Killed in a raid, Bowie was buried in the family cemetery there. In disrepair, the house was demolished, and Wat Bowie's grave was moved to nearby Holy Trinity Church.

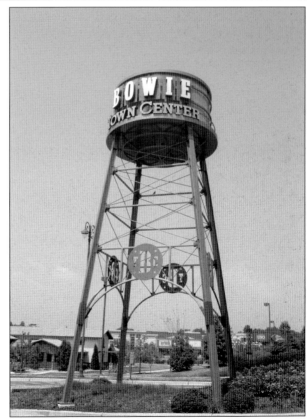

Pictured is the Bowie Town Center water tower. Bowie has been transformed over 60 years from a small rural community to a large suburban development. Today, the Bowie Town Center, which opened in 2001, commemorates Bowie's rich railroad heritage at the center's entrance.

The City of Bowie moved to a new home in April 2011. Designed by Grimm + Parker Architects, the new city hall represents the first time since its beginnings that the city has a home in a dedicated structure. After years of meetings in homes, firehouses, and the Belair Mansion, the new, spacious, environmentally certified structure will serve the City of Bowie for its next 100 years.

Nine

PIECES OF THE PAST

Bowie's cultural history is clearly demonstrated by the diverse objects that inform the present. These are the tangible items of history—used, examined, worn, and in many cases treasured. They comprise the material culture, the "stuff" that gives a sense of life in Bowie from its earliest days, even before it was Bowie.

In 1996, Bowie established a division within city government known as Historic Properties. Prior to that time, beyond a very few objects and a few photographs, there was no collection of Bowie's material history. Since then, generous donors have been forthcoming, and the Historic Properties Division has actively searched for and purchased materials to expand the division's ability to interpret Bowie's long life.

Objects in the Historic Properties collection are as simple as a key chain from the early days of Belair Estate or a match clip from Bowie Race Track. They are as complex as a series of four magnificent English oil paintings from the 1740s that belonged to the Ogle family. They include industrial materials such as a railroad tower interlocking machine and an elegant 18th-century embroidered gentleman's waistcoat that belonged to a member of the Ogle family. They are as massive as a 19th-century mahogany wardrobe and as diminutive as a small knitted pinball made in 1808.

These objects are about people of the distant past and the near past. They define life in Bowie across the centuries.

Painted in the 1760s by famous 18th-century artist John Wollaston, Col. Benjamin Tasker's portrait reflects his standing as gentry and gives a hint as to the bearing of a man respected by other 18th-century Marylanders. At the death of Belair's Samuel Ogle in 1752, Colonel Tasker (the brother of Ogle's wife, Anne) took over management of Belair Plantation.

This small musical instrument is a pump organ or melodeon, typical of the type of instrument young, genteel ladies would have played as a leisure activity in the mid-19th century. Restored to its former beauty, the melodeon is in the Belair Mansion today.

This beautiful, classically inspired urn contains an iron ingot inside, heated to make hot water for filling teapots. Two lion heads support the handles; a laurel wreath is engraved on the front. The urn is an Ogle family antique, purchased by or for Anna Maria Cooke Ogle. It was assuredly on the table for tea service at Belair Mansion during her life.

Made around 1800, this delightful table mirror has an Ogle family history. Purchased by the City of Bowie Museums from a descendant, the mirror tilts, allowing a person to adjust upward to complete his or her toilette.

Made in England by the Derby porcelain makers between 1760 and 1770, this figure may have been one of several purchased by Benjamin Ogle I during his time in England as a student. It represents typical mantle garniture of the 18th century. This piece is a gardener holding a basket of berries, with his dog at his feet. The gardener is one of four Derby/Bow porcelains owned by the City of Bowie Museums and was purchased from an Ogle descendant.

Throughout the 19th century, the creation of needlework "paintings" was a very popular pastime for genteel young ladies. This piece shows a young lady and a young gentleman in a field harvesting wheat. Created about 1790, the needlework is framed under glass painted on the reverse in a technique known as eglomise.

A magnificent c. 1825 wardrobe stands as the most massive piece in the City of Bowie Museums collection. Made of mahogany, the wardrobe was at Belair before being moved to Baltimore in 1871 to the home of an Ogle descendant. At the time of manufacture, its cost was listed at $25.

The utilitarian design of this simple cabinet gives a clue to its history. Family history records that the cabinet was made on Belair Plantation by an enslaved craftsman in the early 19th century. Survivals of furniture with this history are rare.

One of the most conversation-provoking objects in the City of Bowie Museums collection is a late-19th-century fireless cooker. Likely the precursor of today's crockpots, fireless cookers have been used for many centuries. Soapstone disks are heated on the stove, placed with food to be cooked in an opening, and the lid is then closed. After a period of time, the box is opened, and heat from the disks and the insulation of the box provide a nicely cooked dish.

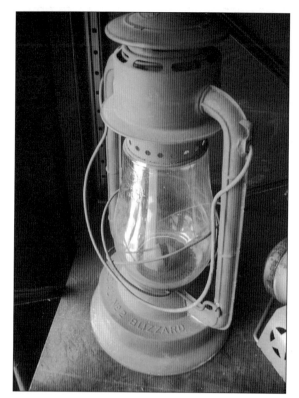

Bowie was born in the 1870s on the railroad. The Bowie Railroad Museum, which commemorates this heritage, contains everyday objects from the rail industry like the Dietz Blizzard Lantern here. Manufactured in the early 20th century, lanterns such as this one were a critical part of lighting along railroad tracks and in railcars.

Very early in Huntington City's history, the Pennsylvania Railroad bought out the rail line's original owner, the Baltimore and Potomac. Printed in 1882, this timetable outlines stops between Boston and Richmond, including Bowie.

Clothing, more than any other item, connects museum visitors to the people of the past. Regardless of style or size, garments are tangible evidence of life over the years. This small child's winter coat, made in the early 20th century, is typical in style and fabric to what the Brady children would have worn while living in the stable master's apartment at Belair Stable.

Belair Stable was the home of James and Gertrude Brady and their children, Thelma and James, for several years beginning in 1923. Made around 1920, the child's shoes here could have been worn by either Thelma or James.

This platter in the blue Onion pattern was made in the early 20th century. It was a gift from Elsie Woodward (Mrs. William Woodward) to Edward and Helen Wintermere, Belair's caretakers.

From 1914 through 1916 (and possibly longer), William Woodward hosted an annual pigeon shoot every fall at Belair. The pigeons were made of clay; the shoot was likely held in Belair's garden. Gentlemen attending the shoot were society friends of the Woodwards from New York City.

No. 55.

PROBATIONER'S CARD

THE GIRLS' FRIENDLY SOCIETY IN AMERICA

"Bear ye one another's burdens."—Gal. vi: 2

Probationer's Name *Mary Thomas*

Enrolled by *H. Marjorie Zug*} Name and Address
Bowie, Md. of Associate

Date of Enrollment *March 6* 19 *26*

May, 1925—4000

Founded in the 19th century by the Episcopal Church, the Girls Friendly Society was an international organization of women—children and adults—whose mission was both philanthropy and the empowerment of young women. St. James Church in Huntington had a very active society led by Marjorie Zug, a local resident.

Although noted as a Thoroughbred farm, Belair functioned also as a working farm raising typical Maryland crops and livestock. The Woodward family owned Shropshire sheep and a significant herd of shorthorn cattle. The ear tags shown here identified each cow or steer in the herd. Mundane in their function, they do give a glimpse of residents of Belair beyond the human population.

Baseball has a long history in both Huntington City and Bowie. Sandlot and Negro League baseball were extremely popular and enjoyed by all. This catcher's mitt was purchased in the 1920s by James Wildman, a resident of Huntington, to give to his son, John. Crafted of leather, it is stuffed with cotton or wool. A leather strap held the catcher's hand in place.

In addition to their passion for Thoroughbred racing, the Woodwards were devotees of foxhunting while at Belair Farm. Prior to the sale of Belair, 65 fox masques such as this one hung on the walls of the mansion's sunroom. All were sold at an estate auction; this one was returned to Belair as a donation.

Radio in the 1930s and 1940s was an incredibly important step in the growth of universal culture. A portable radio like this 1940s Zenith would have not only kept its owner entertained but would also have delivered crucial news to the owner's home as well.

Crafted by sculptress Eleanor Iselin Wade in the 1930s, this elegant equine statue commemorates Belair's Gallant Fox, winner of the 1930 Triple Crown. "The Fox of Belair," as he was often called, is said to have been William Woodward's favorite horse of all his excellent equines. Gallant Fox is the only Triple Crown winner to sire a Triple Crown winner. His son Omaha captured the crown in 1935.

Bowie Race Track opened in 1914. Through the years, it provided thousands of Thoroughbred racing fans with excitement and an opportunity to "play the ponies." Special race trains ran to the track, and locals visited as well. A day at the races could be, with a winning ticket, very profitable.

Through the early 1950s, the Woodward family enjoyed the sport of trapshooting right in Belair's garden behind the house. A 1990s archaeological investigation yielded many fragments of clay disks like this one. This intact disk was one of a number of them given to farm manager Gabriel "Flick" Nalley at the sale of Belair Farm in 1957.

Objects from the past are large and small, some elegant, some mundane. In the City of Bowie Museums collection, objects include images of the people who lived within the walls that surround visitors today at all museum sites. Thelma Brady Gasch is pictured here around 1924. As a small child, she lived at Belair Stable. Her image gives a face to the past.

BIBLIOGRAPHY

Arnett, Earl, Robert J. Brugger, and Edward C. Papenfuse. *Maryland: A New Guide to the Old Line State*. Baltimore: Johns Hopkins University Press, 1999.

Baltz, Shirley V. *Belair from the Beginning*. Bowie, MD: City of Bowie Museums, 2005.

Barrett, Heather L., Lori Dempsey, Jaime Jacobs, Mikhaila X. Mikel, Kristen O'Connell, and Shannon L. Papin. "Belair-at-Bowie." Washington, DC: George Washington University American Studies Program, 2000.

Council of Maryland Proceedings. April 2–21, 1649, vol. 1, page 244. Maryland State Archives: http://aomol.msa.maryland.gov. Retrieved December 9, 2015.

Council of Maryland Proceedings. October 23, 1696, vol. 23, pages 17–23. Maryland State Archives: http://aomol.msa.maryland.gov. Retrieved August 25, 2015.

Hienton, Louise Joyner. *Prince George's Heritage: Sidelights on the Early History of Prince George's County, Maryland 1696–1800*. Hyattsville: Maryland Historical Society, 1972.

Huntington Heritage Society. *Town of Bowie, Maryland 1870–1960*. Bowie, 1992.

James A. Jacobs. "Beyond Belair." In *Housing Washington: Two Centuries of Residential Development and Planning in the National Capital Area*, edited by Richard Longstreth. Chicago: Center for American Places at Columbia College Chicago, 2010.

US Geological Survey, Geographic Names Information System. Feature Detail Report for Collington. http://geonames.usgs.gov. Retrieved August 25, 2015.

Discover Thousands of Local History Books Featuring Millions of Vintage Images

Arcadia Publishing, the leading local history publisher in the United States, is committed to making history accessible and meaningful through publishing books that celebrate and preserve the heritage of America's people and places.

Find more books like this at
www.arcadiapublishing.com

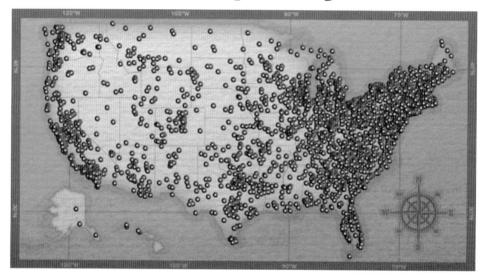

Search for your hometown history, your old stomping grounds, and even your favorite sports team.

Consistent with our mission to preserve history on a local level, this book was printed in South Carolina on American-made paper and manufactured entirely in the United States. Products carrying the accredited Forest Stewardship Council (FSC) label are printed on 100 percent FSC-certified paper.

MADE IN THE